TENNESSEE
Wonder and Light

PHOTOGRAPHY BY
NYE SIMMONS

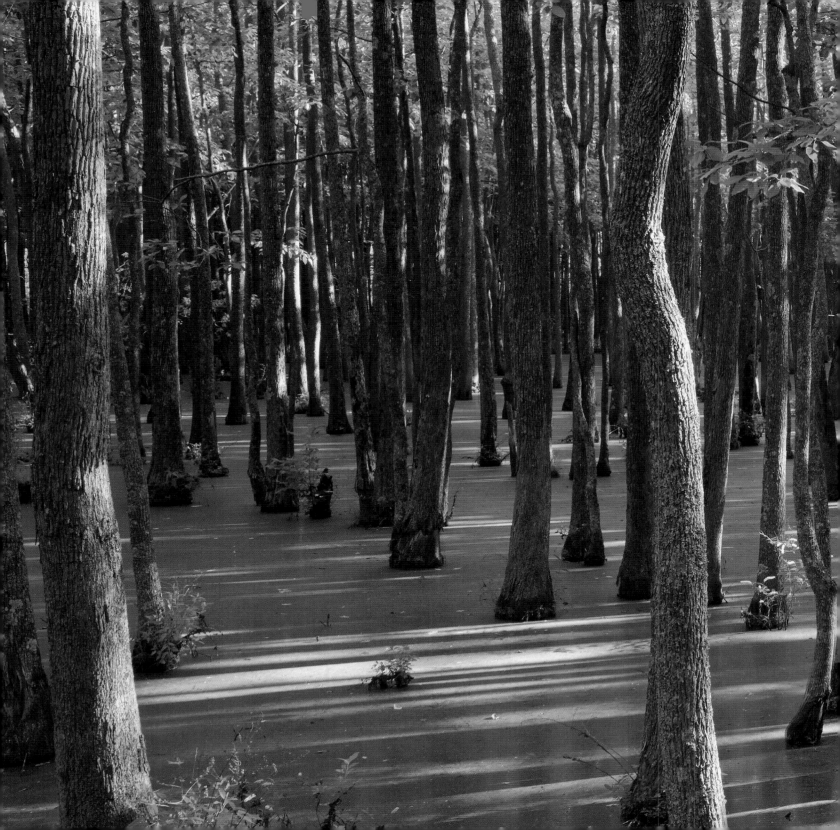

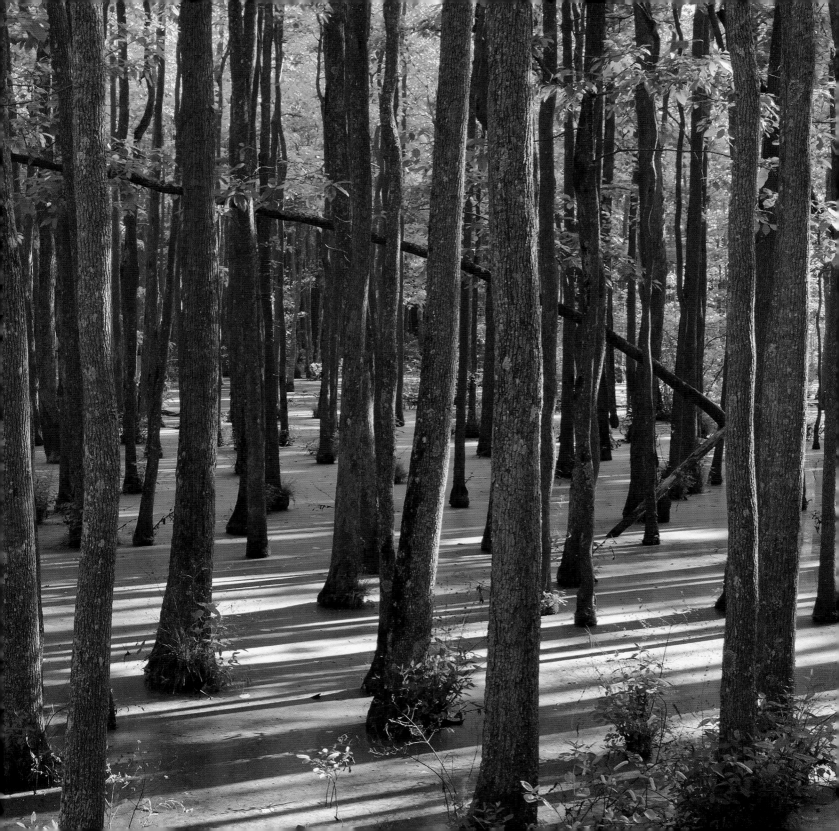

TENNESSEE
WONDER AND LIGHT

Photography by
Nye Simmons

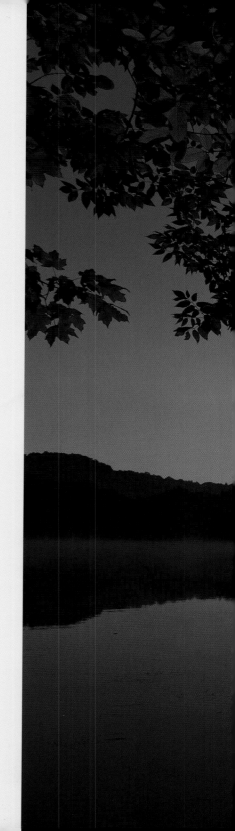

Mountain Trail Press

1818 Presswood Road • Johnson City, Tennessee 37604
www.mountaintrailpress.com

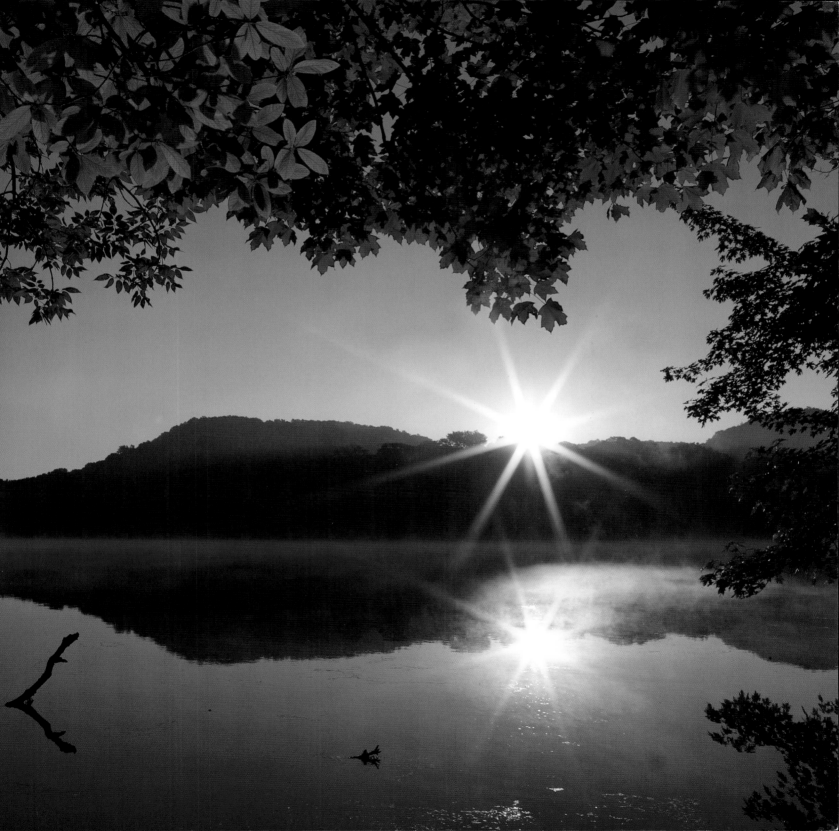

Nye Simmons

Book design: Ian J. Plant
Entire Contents Copyright © 2006 Mountain Trail Press LLC
Photographs © Nye Simmons
All Rights Reserved
ok may be reproduced in any form without written permission from the publisher.
Published by Mountain Trail Press LLC.
1818 Presswood Road
Johnson City, TN 37604
ISBN: 0-9770808-4-6
Printed in Korea
First Printing, Spring 2006

cover: Foothills Parkway overlooking the Great Smoky Mountains.
Title page: Tremont, Great Smoky Mountains National Park.
Full page spread: Mineral slough tupelo forest, Wolf River.
Previous page: Radnor Lake State Park.
Right: Laurel Falls.
bove: Blooming dogwood and redbud, Rock Island State Park.

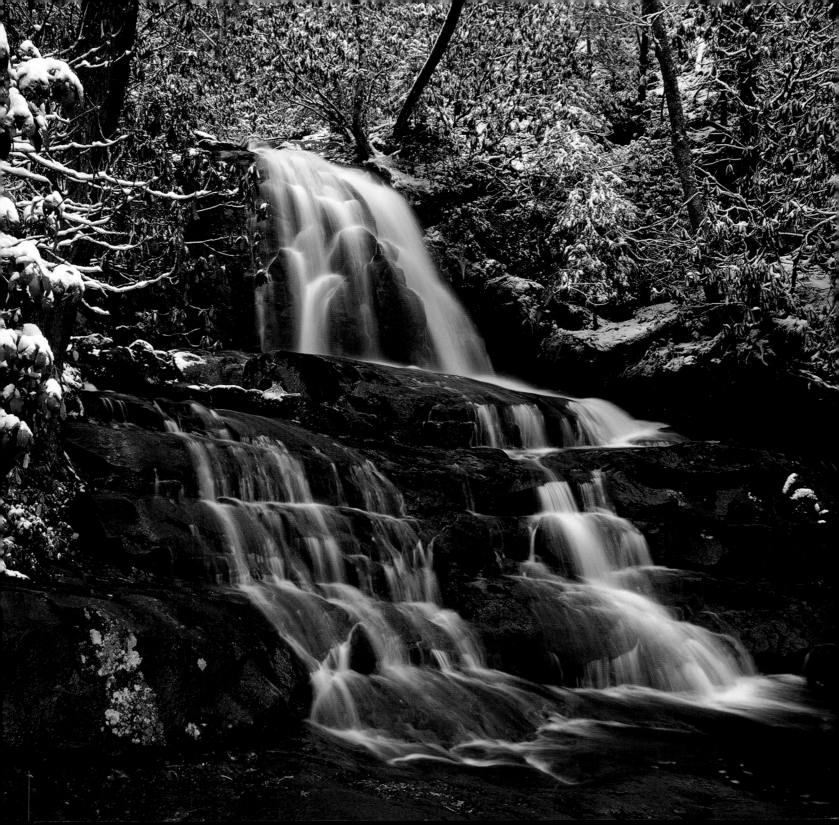

THIS WONDERFUL STATE of Tennessee, rich in history and culture, is also blessed with a diverse landscape ranging from the banks of the "Big Muddy" - the Mighty Mississippi River - at 178 feet above sea level, to the peak of Clingmans Dome, 6,643 feet tall. My personal journey took an erratic course through Tennessee's eastern mountains in the late 70s and early 80s following pack trails and paddling wild rivers. I eventually moved to Knoxville in 1986, following those wild calls and a subconscious homing beacon, as my grandfather had called Tennessee home for many years.

For me, photography gradually replaced whitewater sport, and with the Smokies as my backyard, many rolls, and later sheets of film burned through the camera. With such a seductive neighbor, it was hard to venture further afield, yet gradually I experienced the many scenic wonders of the Big South Fork, the Highlands of the Roan, and the waterfalls of the Cumberland Plateau. Later I discovered the pleasures of Reelfoot, Shelby Forest, and the Wolf River. I found, at every turn, beauty that I didn't know existed, sometimes subtle, sometimes startling. Each area has its own unique character and charm.

Introduction

by Nye Simmons

Many years ago the environmental paradigm shifted from consumption to preservation, arguably after everything worth cutting down, had been. Time heals most wounds, and with the efforts of many tireless people we have in our state a fine collection of protected enclaves to enjoy and pass on to the generations that will follow. But new threats to the sanctity of these special places continue to appear, and old ones are not gone. The chain saw is not yet quiet on our public lands, as though to be "healthy" a forest needs to become "board feet". Insect pests loom now as an even greater threat, names difficult to pronounce but no less deadly to our Southern forest ecosystems: adelgid, anthracnose, the list grows. Development threatens the very views we hold dear; ridge line and valley alike face an invasion of vacation homes, many conspicuously located to proclaim the good fortune of their owners.

These places will stay safe for Tennessee only as long as you and I care enough to keep them that way. Take time to visit these special places, to enjoy them, and pass them on to our children in better condition than they are now. This is our natural heritage, ours to squander or to protect and preserve. The choice lies before us. I hope these images will speak more clearly than words.

In lasting and loving memory of Paul Rosenzweig, Bernard H. "Bootsie" Rosenzweig, and Charlotte R. "Jenny" O'Flarity. Cousins, a generation apart, separated by years and miles, loved not less.

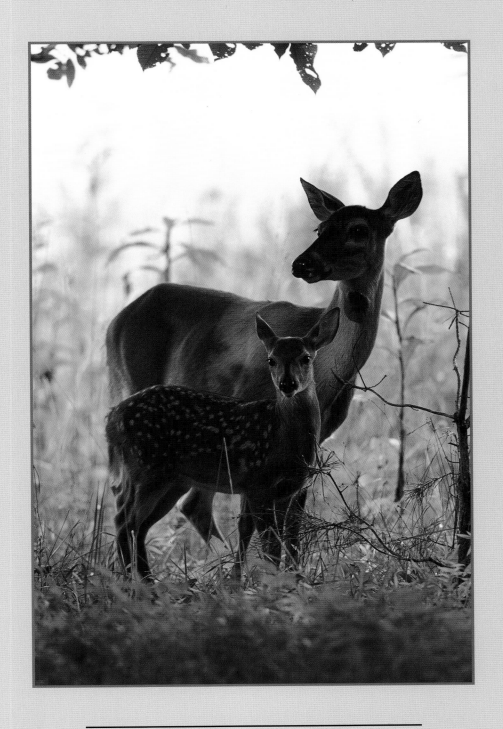

A doe and her fawn enjoy the cool morning air. Cades Cove,
Great Smoky Mountains National Park.

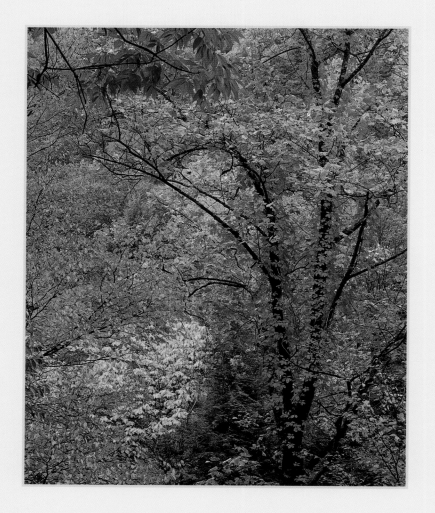

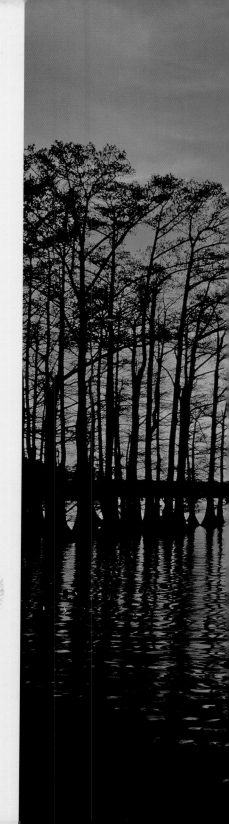

R EELFOOT LAKE was created by a series of earthquakes during the winter of 1811-1812. Large areas of land sank and filled with water, creating the 25,000 acre lake. Today the lake is dominated by bald cypress trees, which thrive in southern swamps and lakes.

Above: Virginia Creeper turns crimson as autumn approaches.

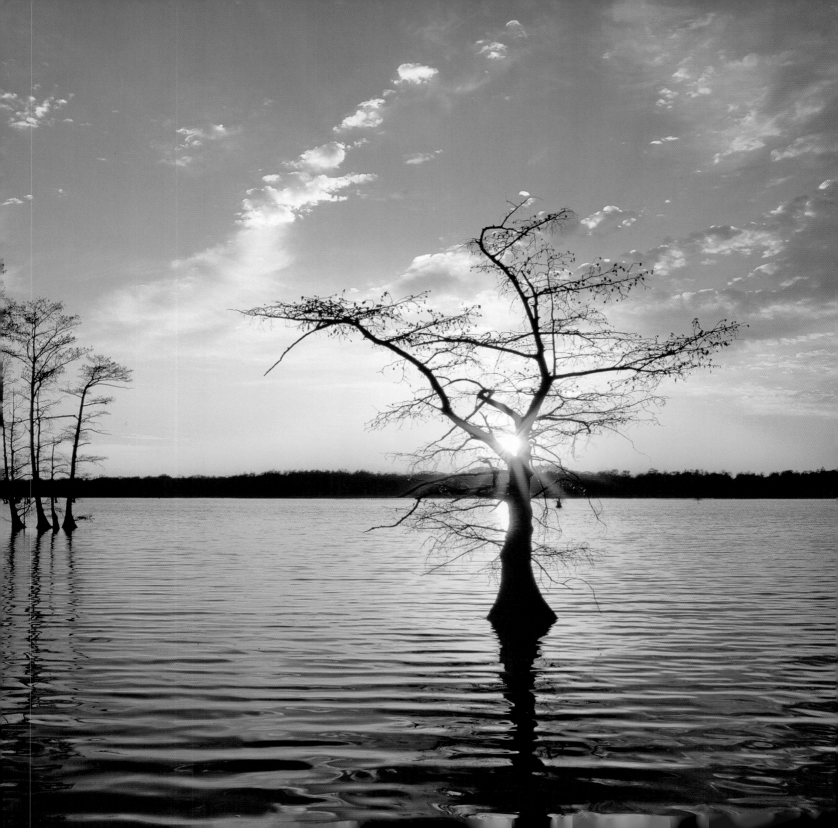

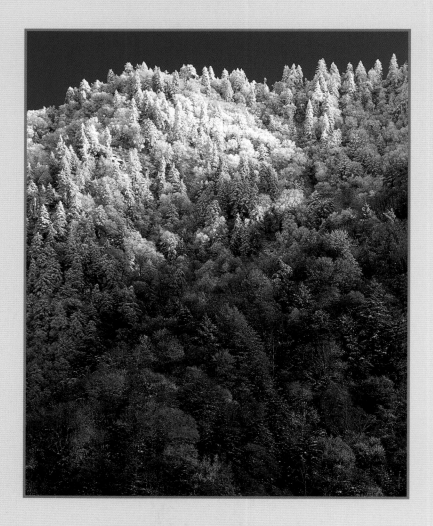

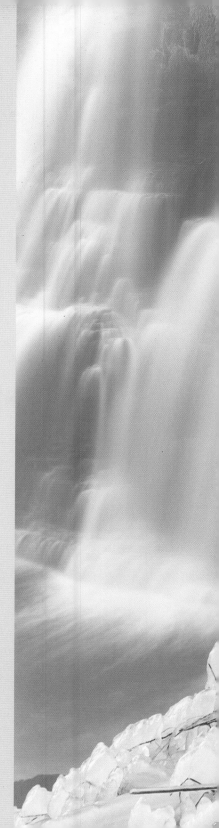

ICE SCULPTURES FORM at the base of Burgess Falls in Burgess Falls State Park. Located in Middle Tennessee, the Park lies on the eastern edge of Tennessee's Highland Rim adjacent to the Cumberland Plateau.

Above: Snow gilds the higher elevations of the Great Smoky Mountains in Eastern Tennessee.

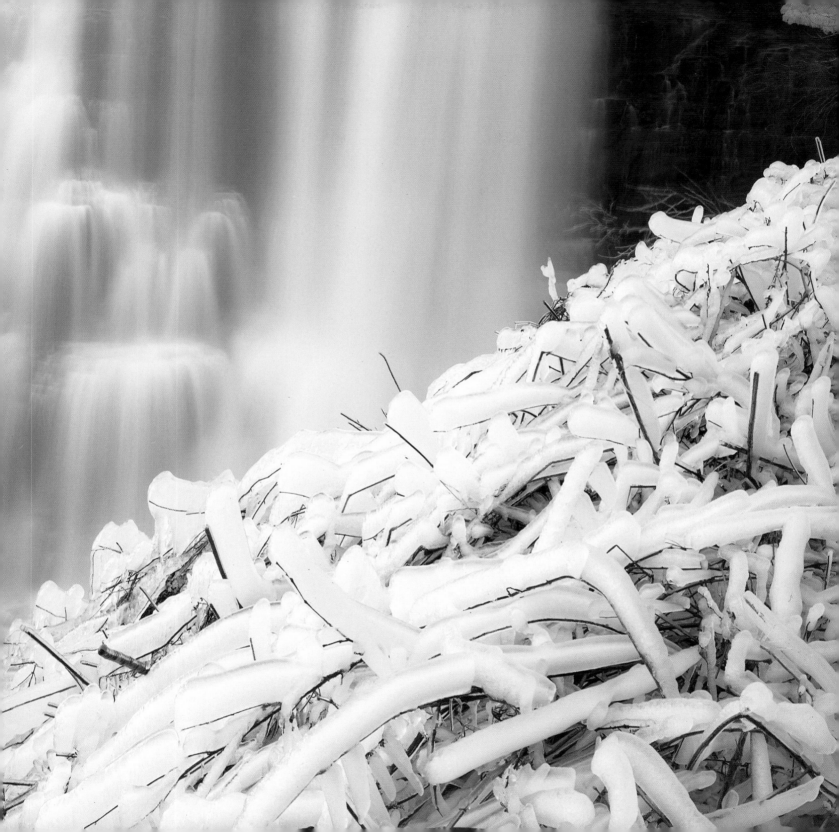

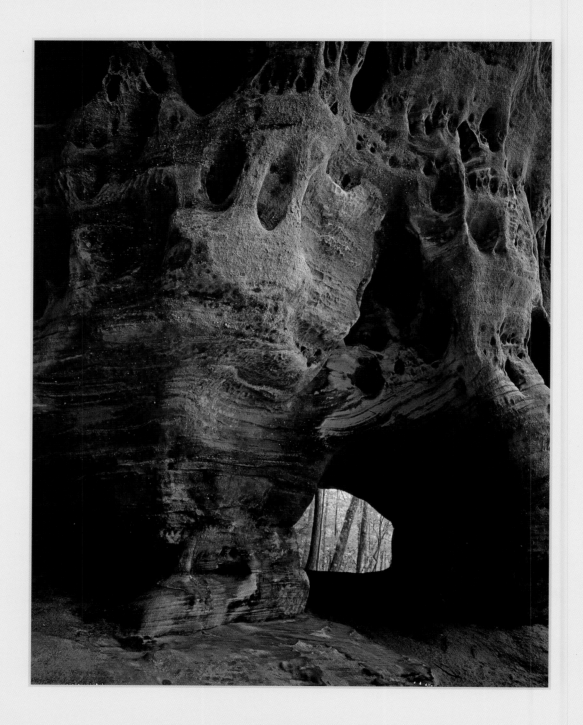

Natural arches ranging from window size to the massive span
of Twin Arches dot the northern Cumberland Plateau.

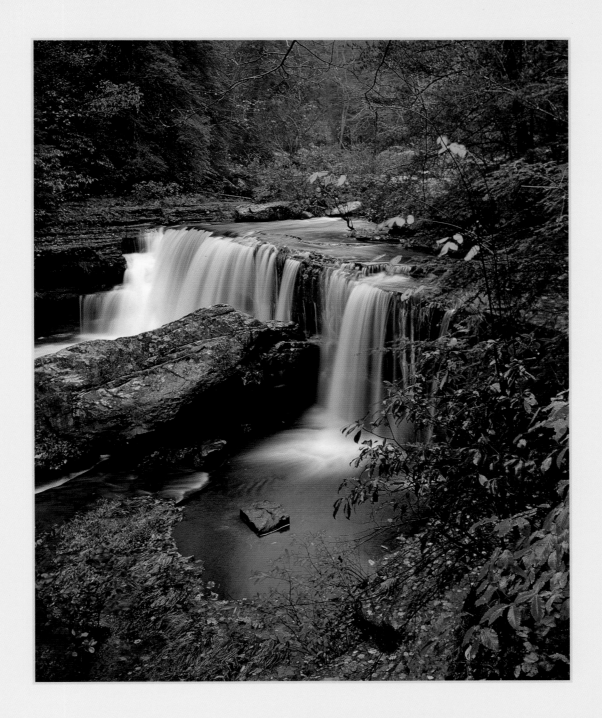

Upper Greeter Falls, located in South Cumberland State Park.

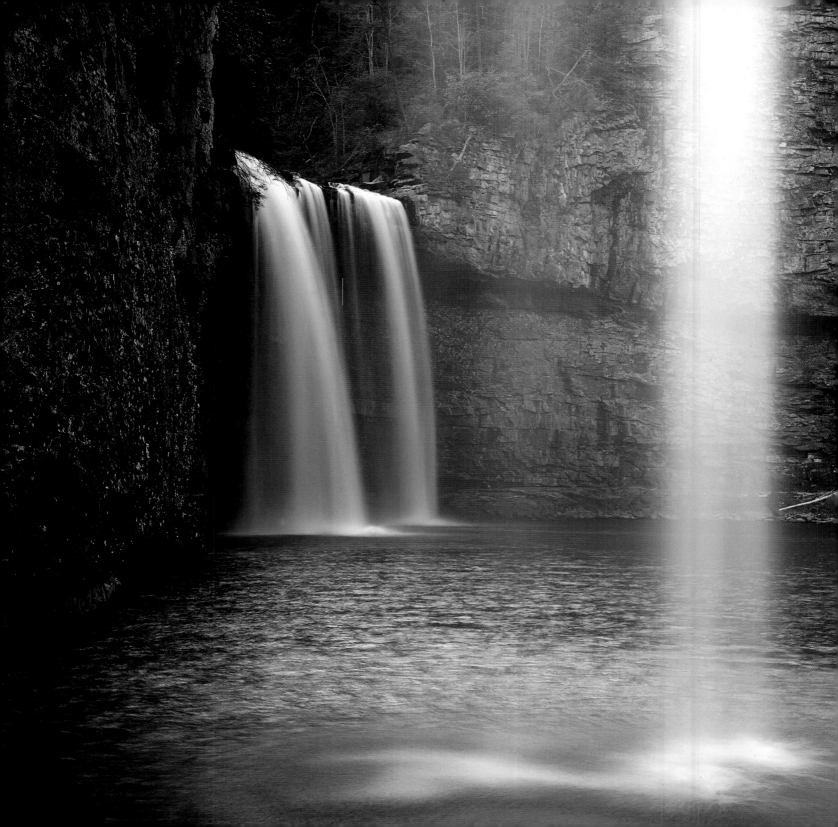

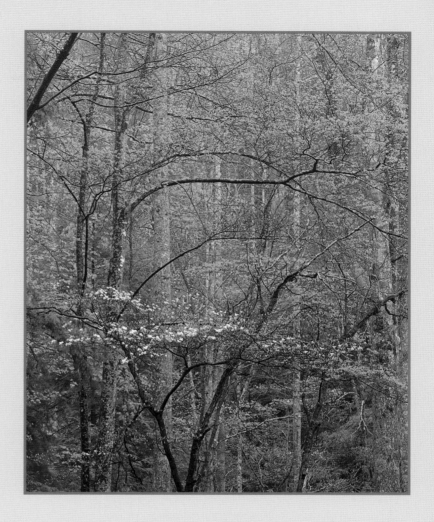

F ALLS CREEK FALLS PARK contains a number of dramatic waterfalls, including Cane Creek and Rockhouse Falls, featured at left.

Above: Spring buds come to the Cherokee National Forest.

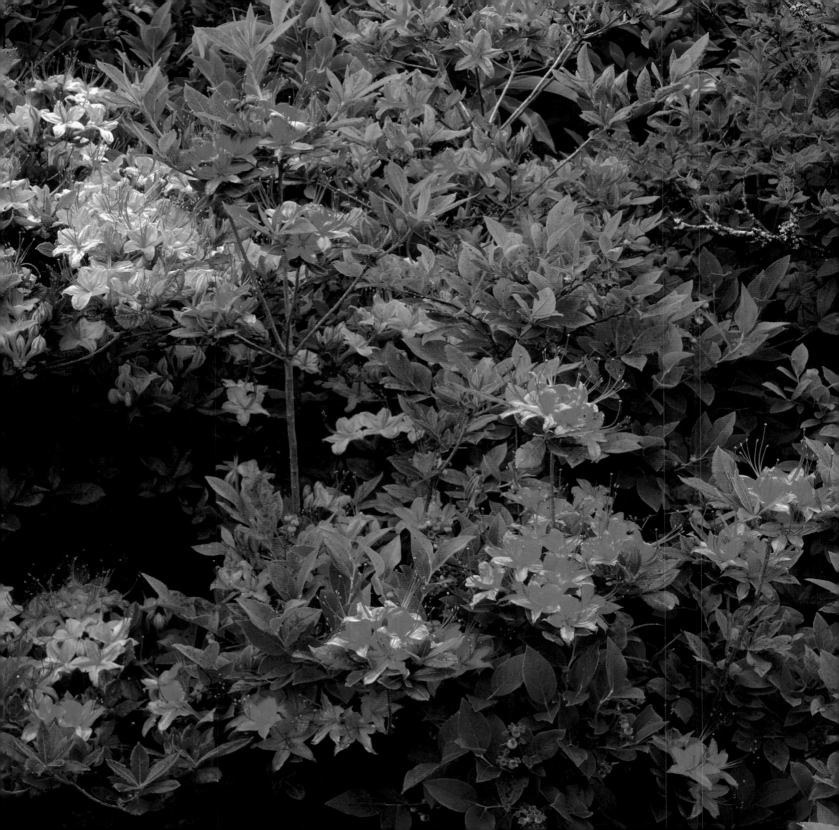

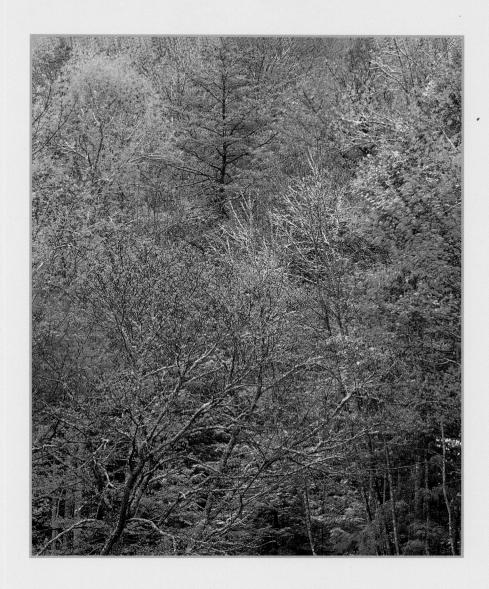

F LOWERING TREES and shrubs bloom in profusion in the
Southern Appalachian Mountains, including this patch of
flame azalea on Gregory Bald in the Great Smoky
Mountains. Flame azaleas bloom in a myriad of fiery
shades, including orange, red, and pink.

Above: Redbud blooms pink in spring.

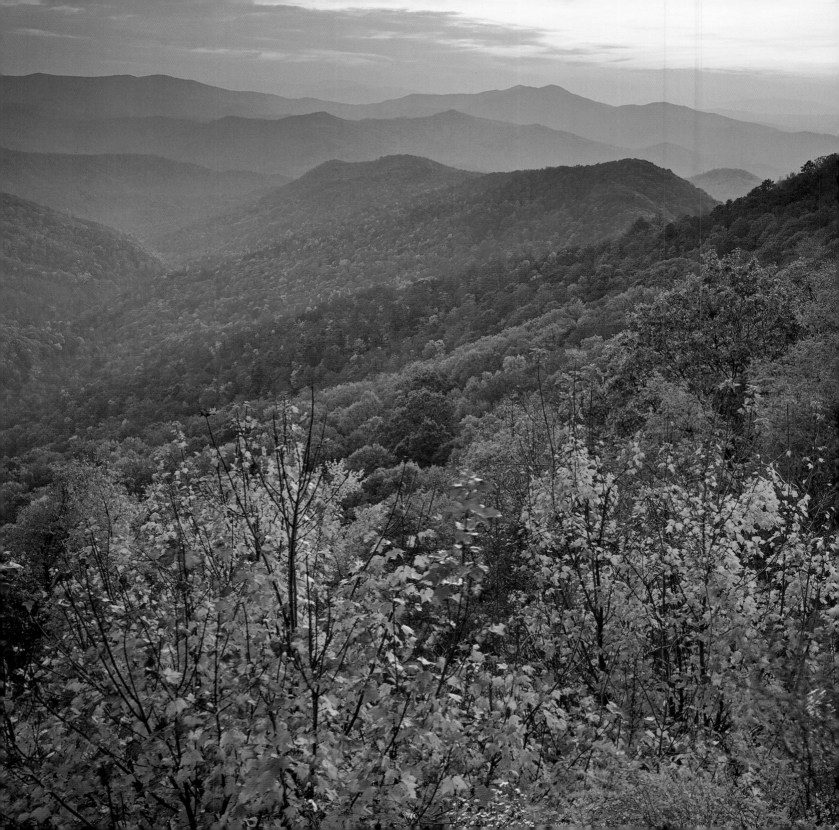

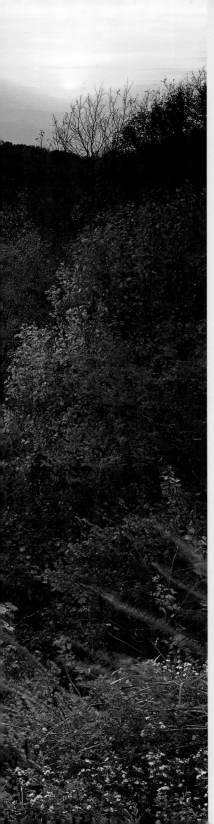

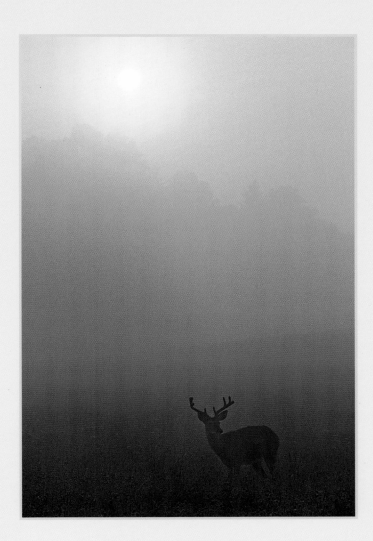

AUTUMN COMES TO THE UNICOI Mountains with a bold splash of reds, oranges, and yellows. This view is accessed from the Cherohala Skyway, which winds for 36 miles through North Carolina and Tennessee.

Above: A whitetail buck stands beneath the rising sun burning through morning fog in the Great Smoky Mountains.

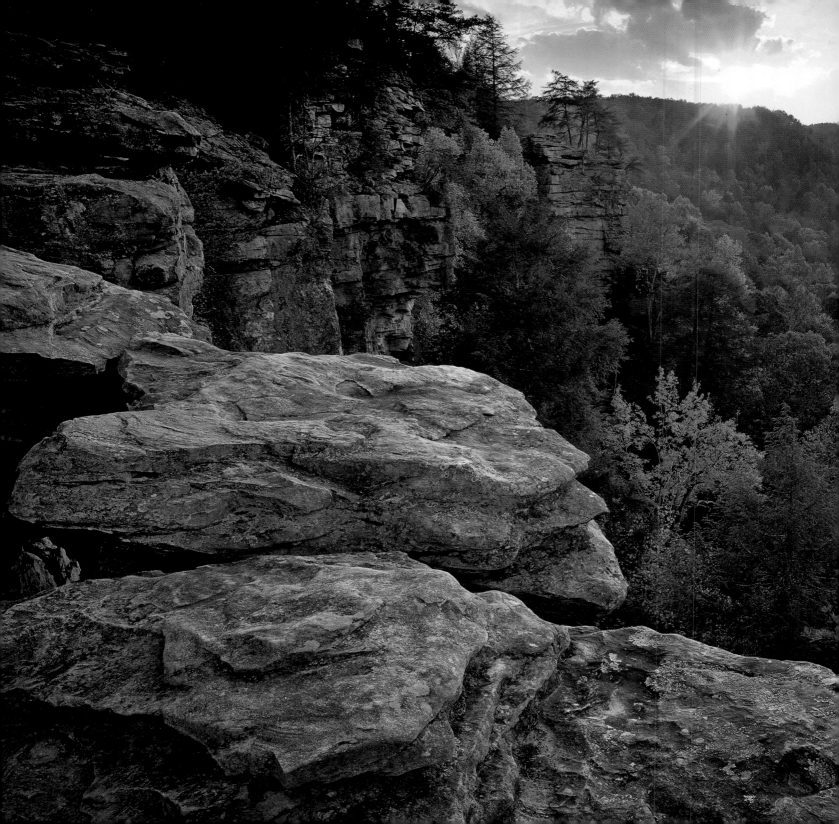

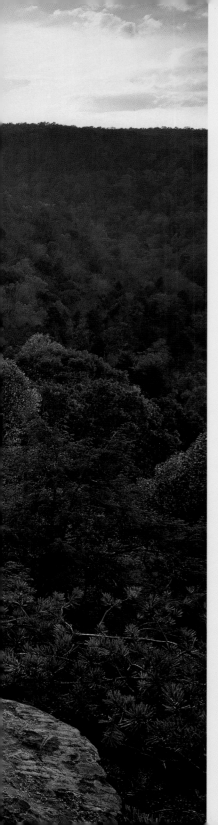

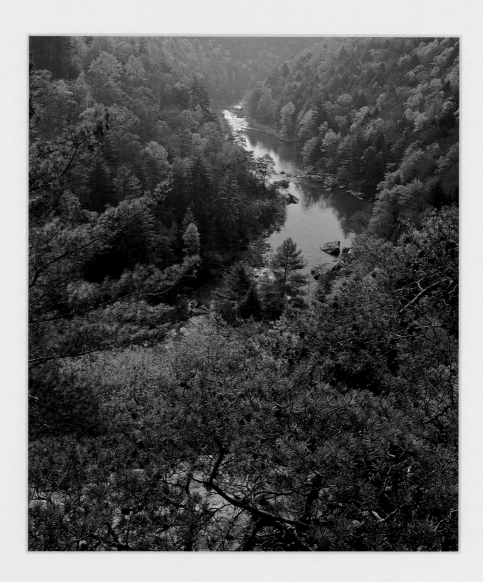

A VIEW FROM Falls Creek Falls State Park. Rocky outcrops such as these are common in Tennessee, but few views are as spectacular as this one.

Above: A view of Clear Creek, part of the Obed Wild and Scenic River, located in Morgan and Cumberland Counties in East Tennessee on the Cumberland Plateau.

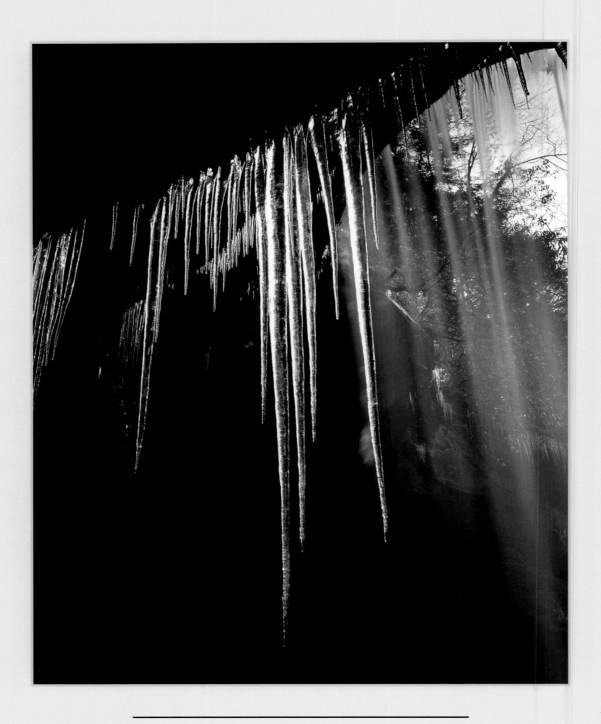

Icicles, like dragon's teeth, hang from a rockhouse rim,
Coldtiz Cove State Natural Area.

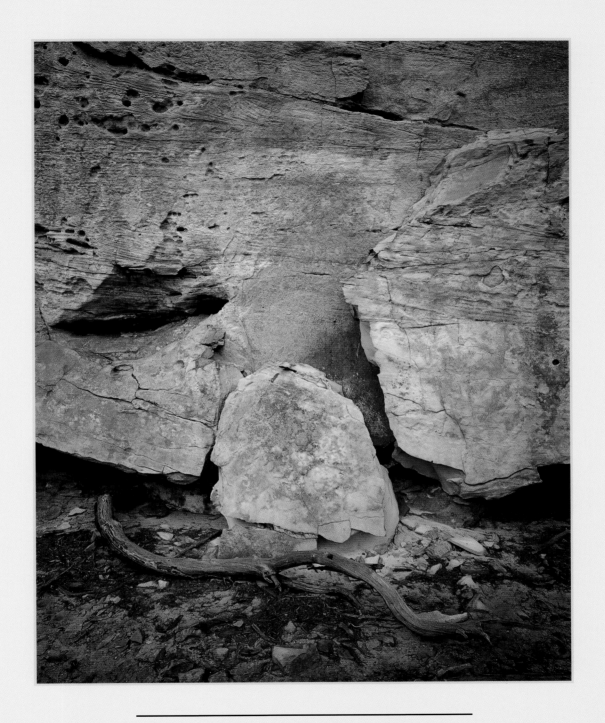

"Not yet written" - reminiscent of a Biblical tablet, a chunk of
sandstone lies waiting. Pogue Creek, Cumberland Plateau.

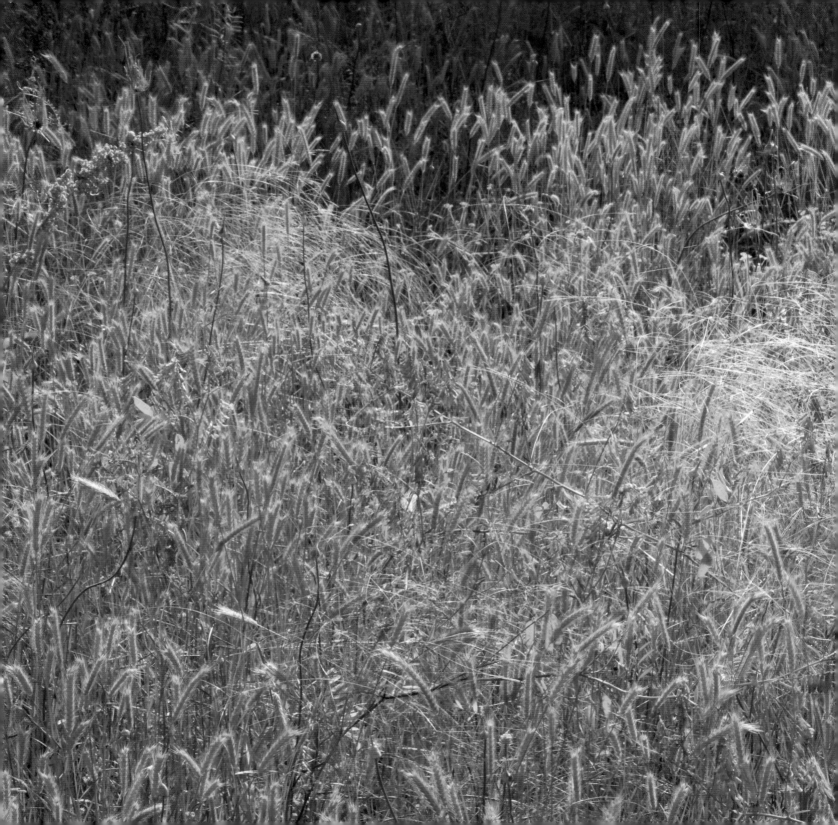

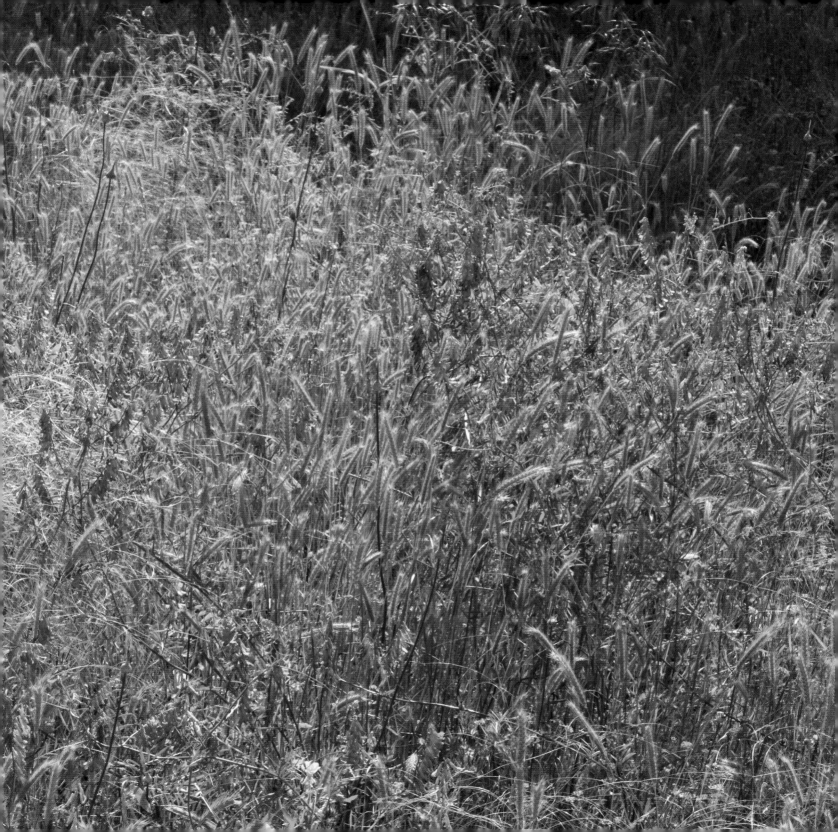

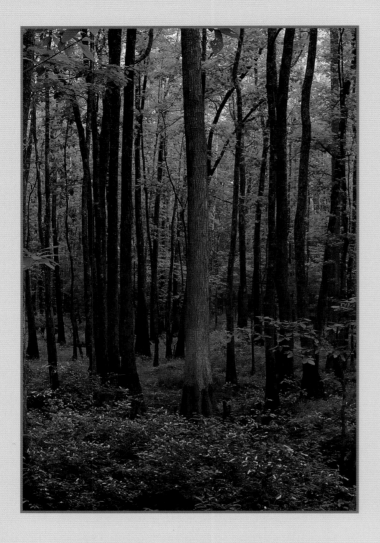

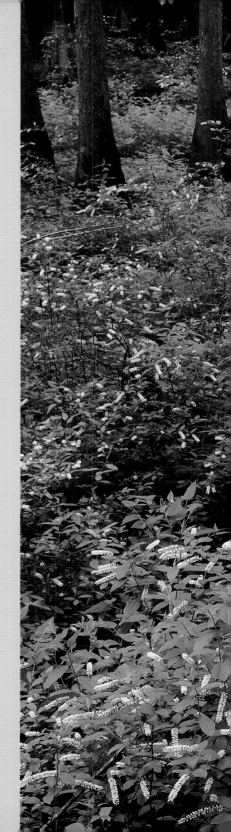

VIRGINIA WILLOWS grace the understory of this bottomland tupelo and cypress forest, William B. Clark Conservation Area.

Above: Another forest view from the William B. Clark Conservation Area.

Previous page: Grasses and sweet vetch thrive in open meadows.

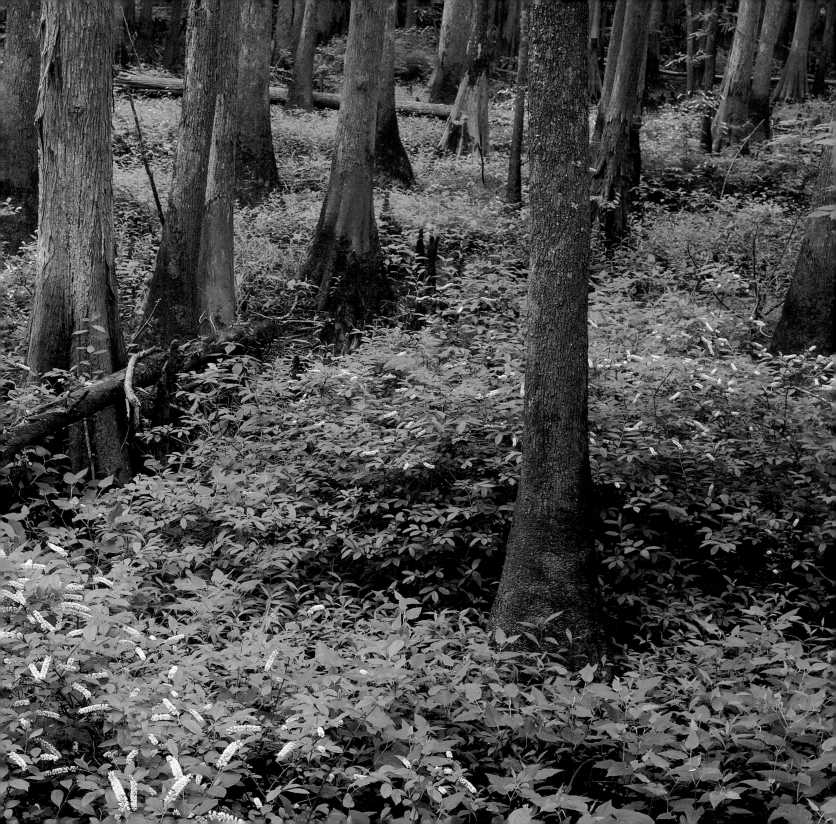

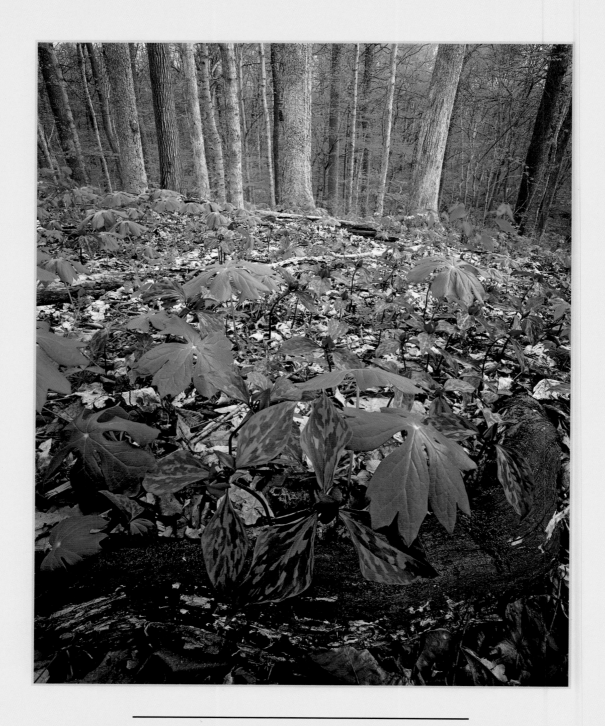

Wakerobin announce that spring is here,
Meeman-Shelby Forest.

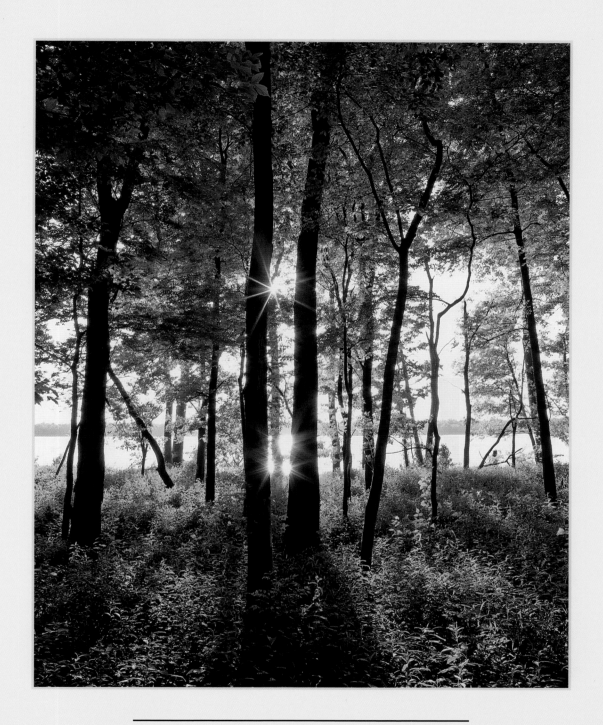

Bottom land is frequently scoured by high water along the
banks of the Mississippi River, Meeman-Shelby Forest.

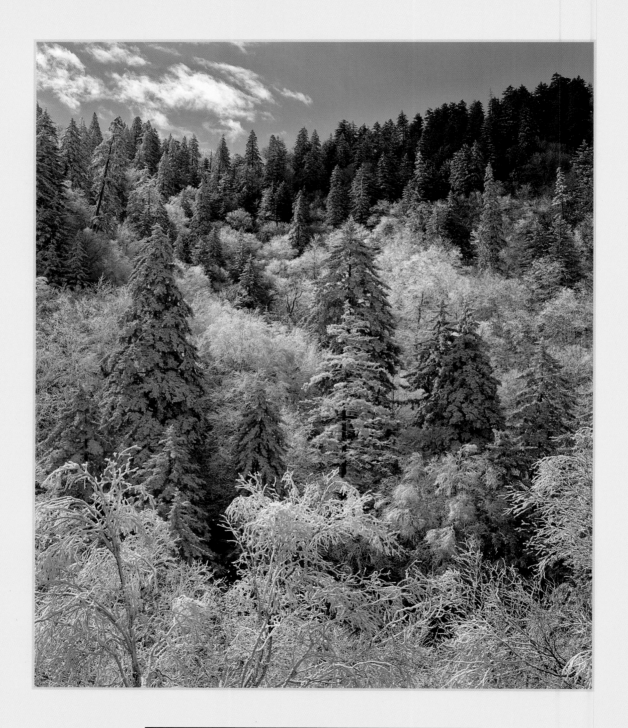

Winter hoarfrost, Great Smoky Mountains National Park.

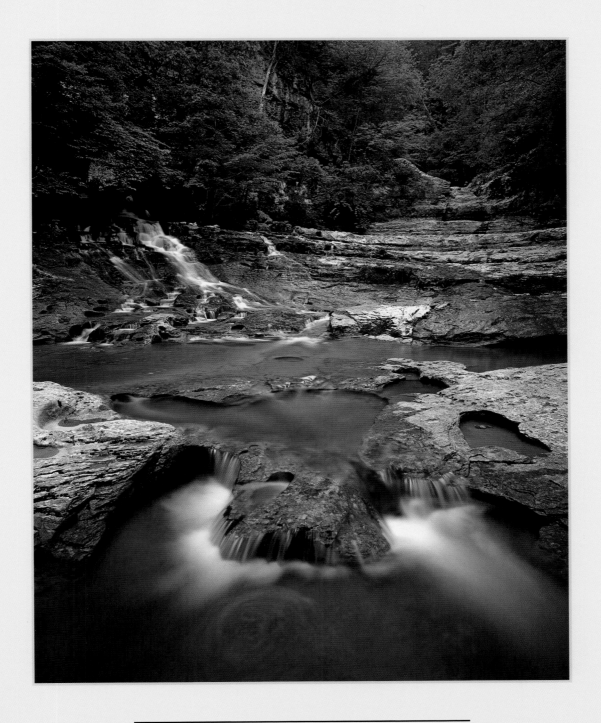

Once home and hunting ground for Davy Crockett, the Walls
of Jericho are now open to public access through the
conservation efforts of The Nature Conservancy.

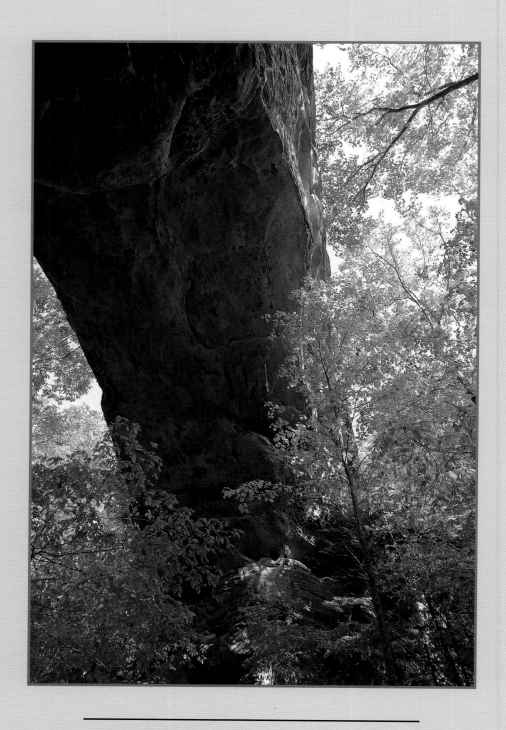

Twin Arches form the largest natural bridge complex known
in Tennessee, possibly in the Eastern United States.
Big South Fork National River and Recreation Area.

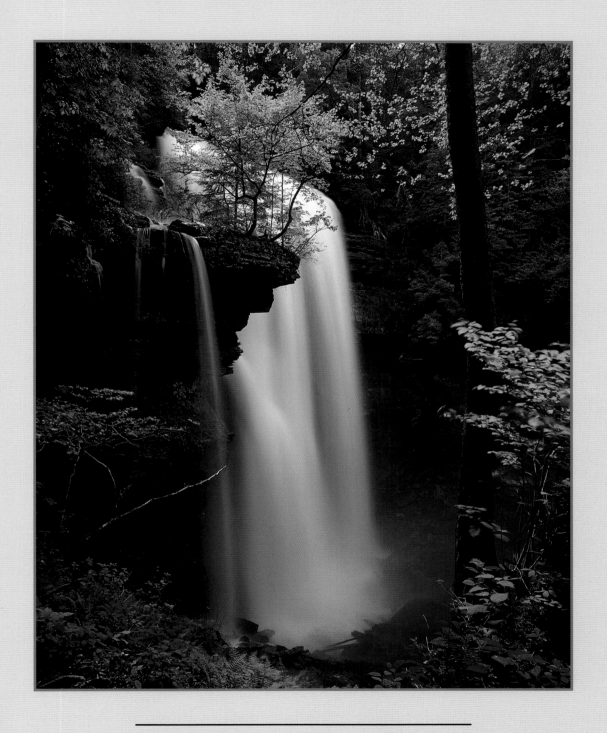

Virgin Falls is formed by an underground stream that emerges
from a cave, drops over a 110 feet high cliff, and then
disappears into another cave.

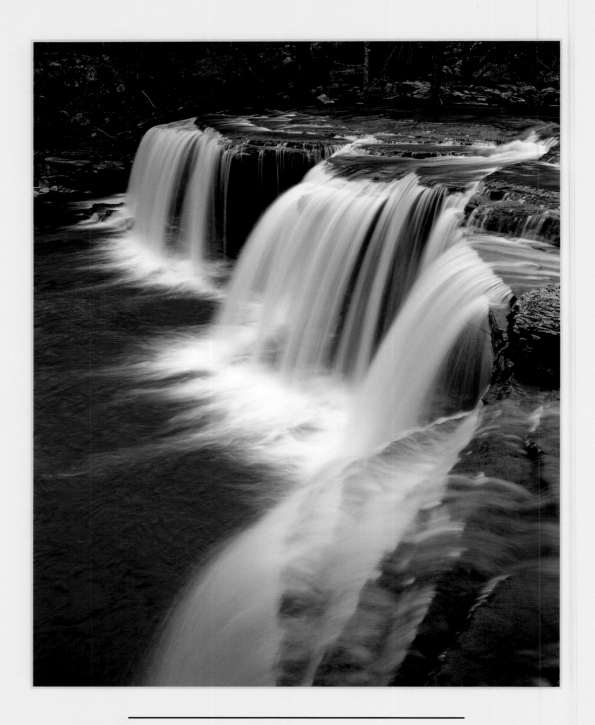

Potters Falls, one of two large falls on the Crooked Fork, a
tributary of the Emory River.

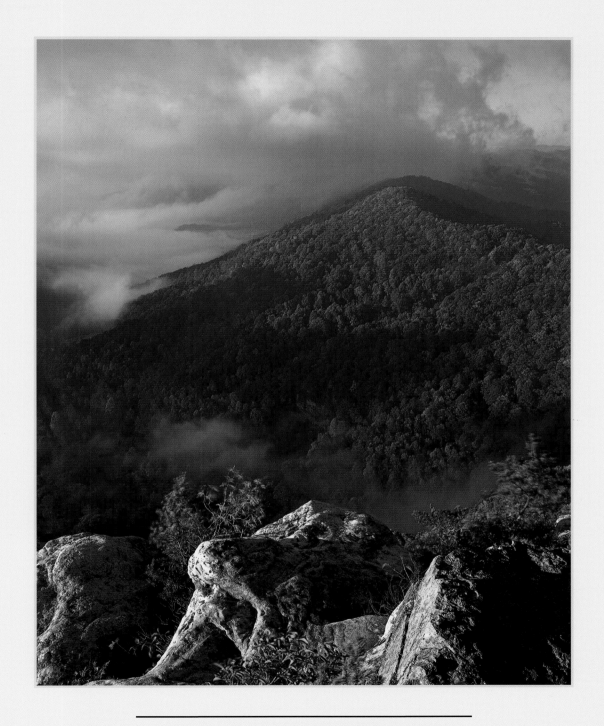

View of Cumberland Gap from the Pinnacle viewpoint,
Cumberland Gap National Historic Park.

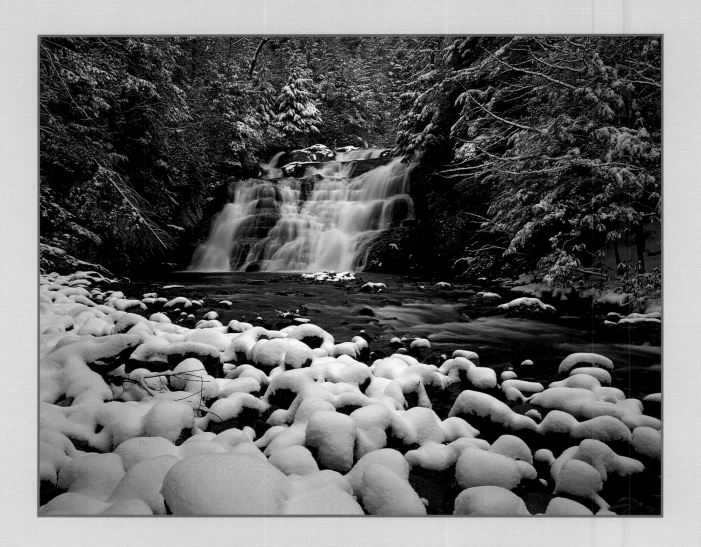

W INTER COVERS birch and rock with snow and ice.

Above: There are many "Laurel Falls" in East Tennessee.
This one is in Pond Mountain Wilderness Area, on Laurel
Fork Creek, near Hampton.

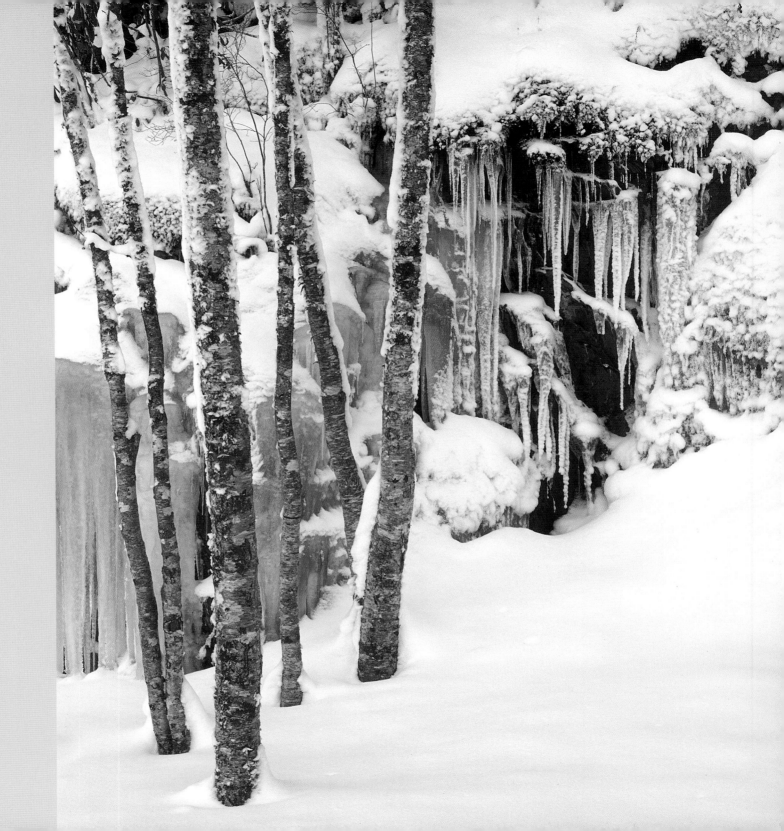

B LACK BEARS are making a comeback in
Tennessee. The population was decimated in the
early 1900s by loss of habitat; the protection of
several key wildlife areas, including Great Smoky
Mountains National Park, has helped the
population rebound. Today there are over 1500
black bears in Tennessee.

Next page: Sunset casts a warm glow over the
autumn-covered slopes of the Unicoi Mountains,
as seen from the Cherohala Skyway.

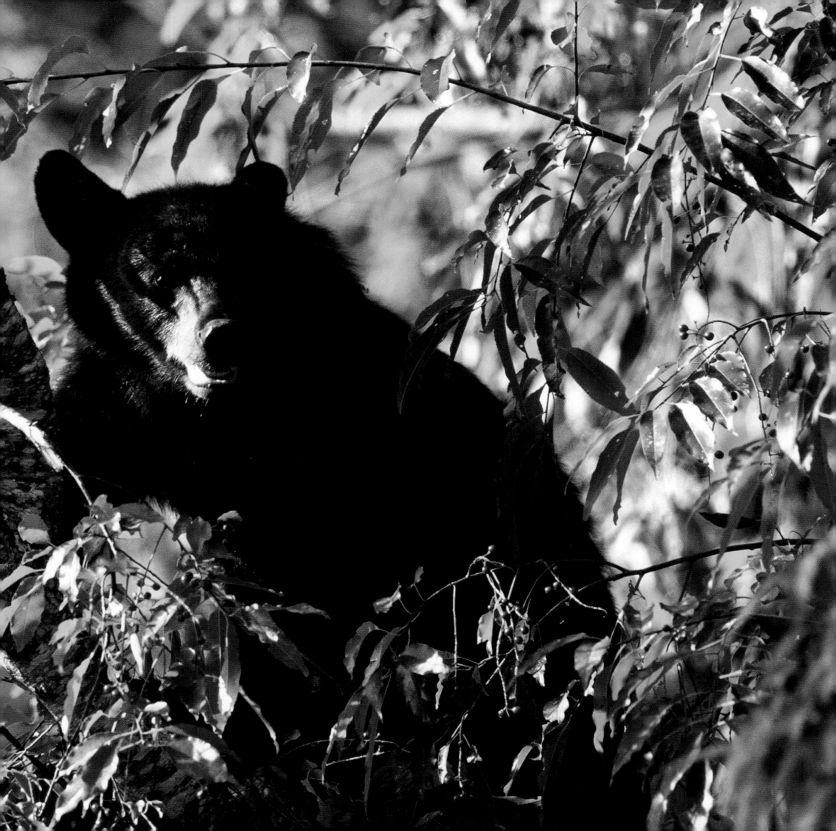

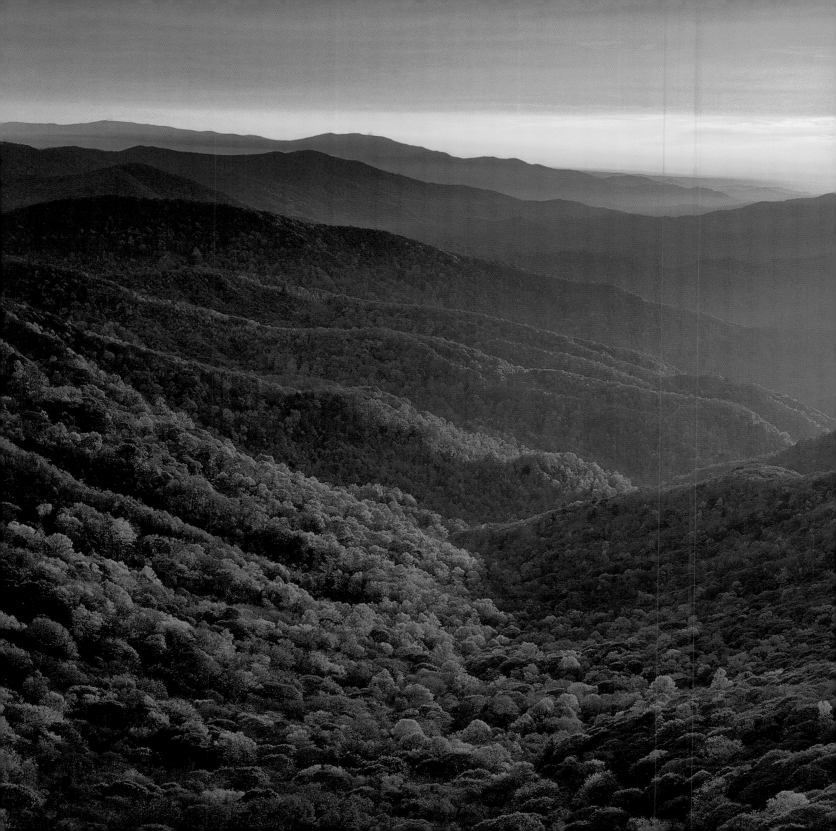

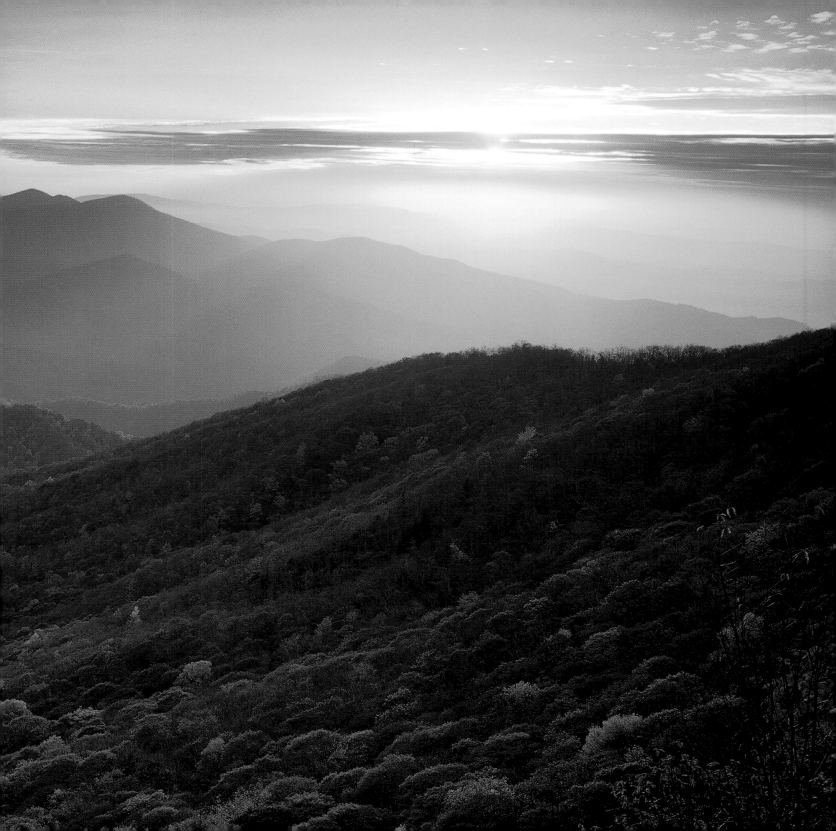

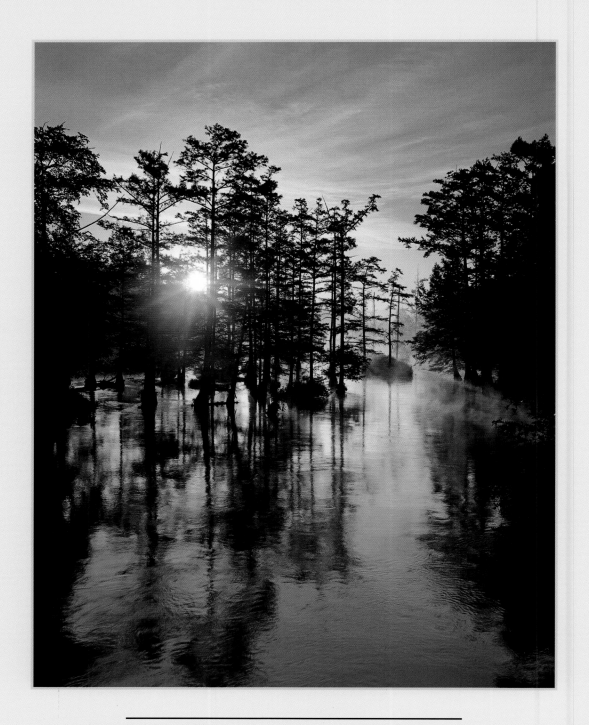

Early morning light shines warmly through a cypress forest,
Wolf River.

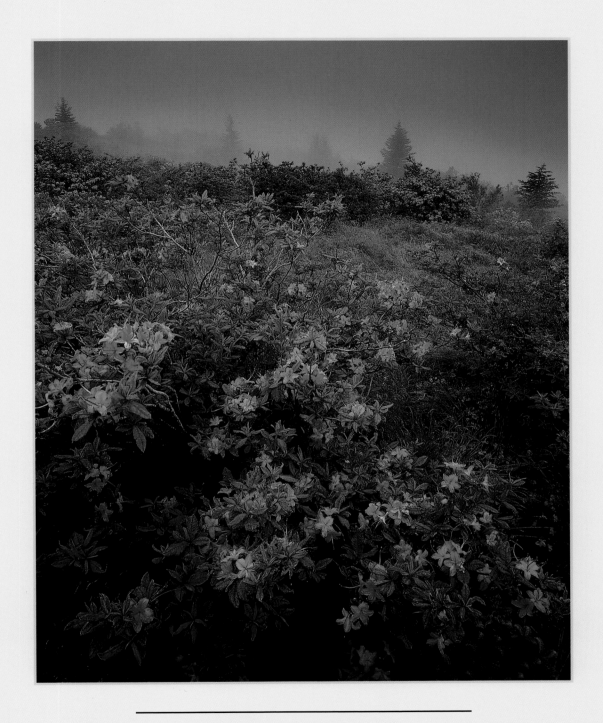

Flame azalea blooms in profusion at Engine Gap,
Roan Highlands.

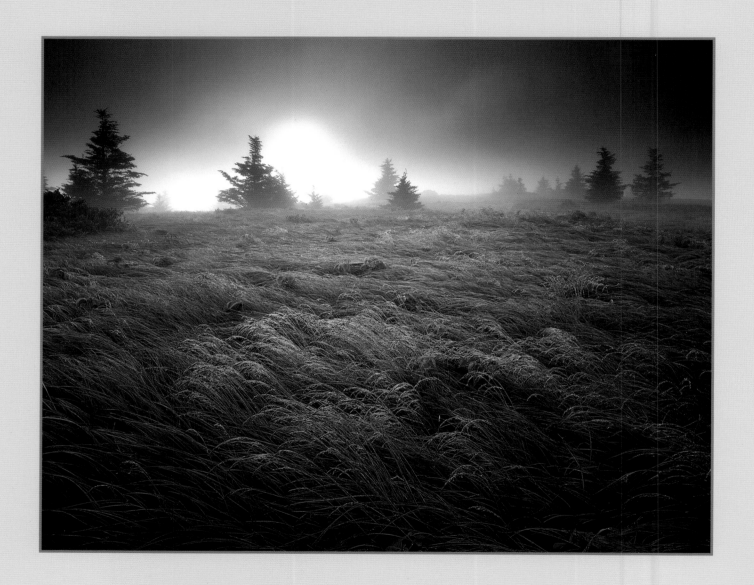

A foggy sunrise over flowing grasses on Roan Mountain.

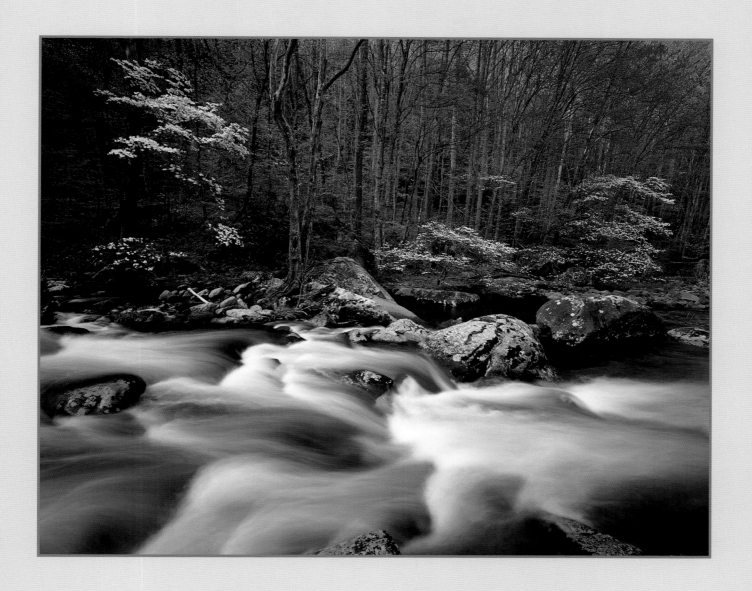

Middle prong of the Little River in Tremont,
Great Smoky Mountains.

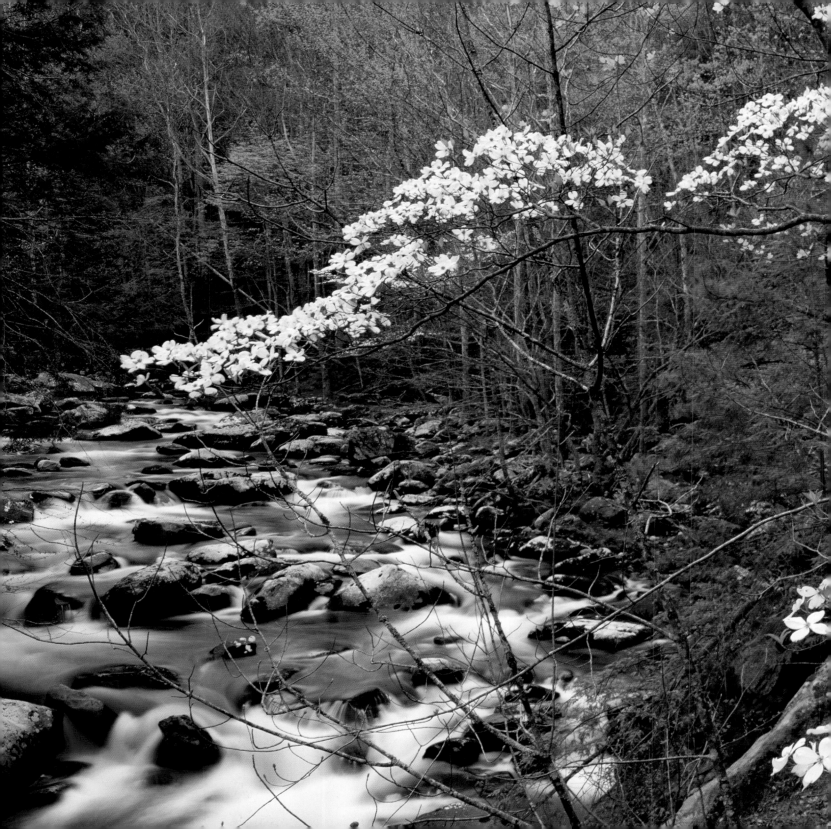

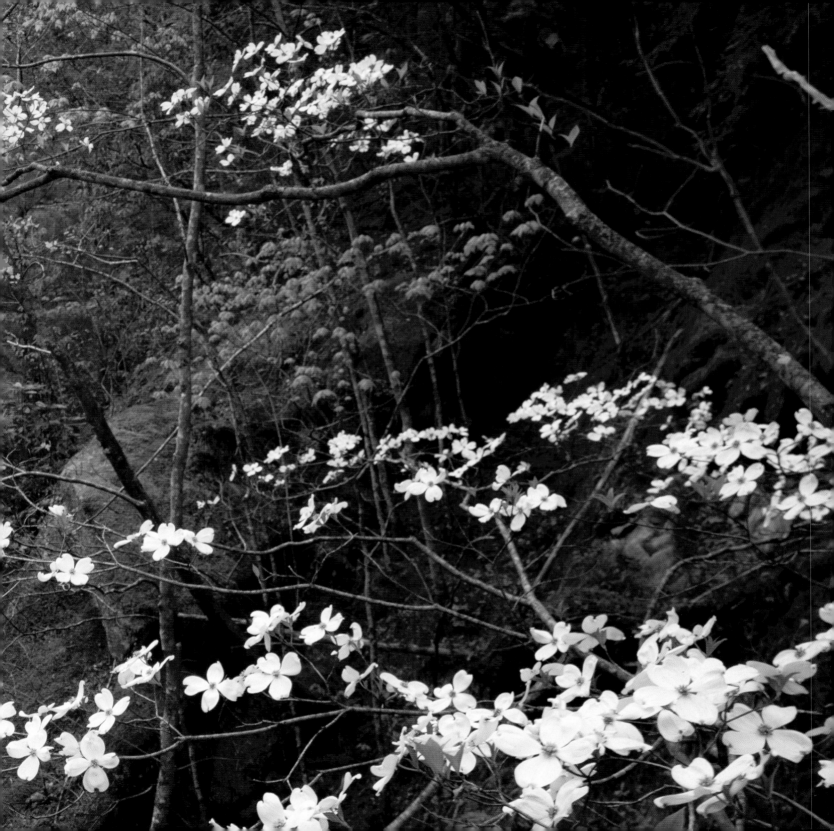

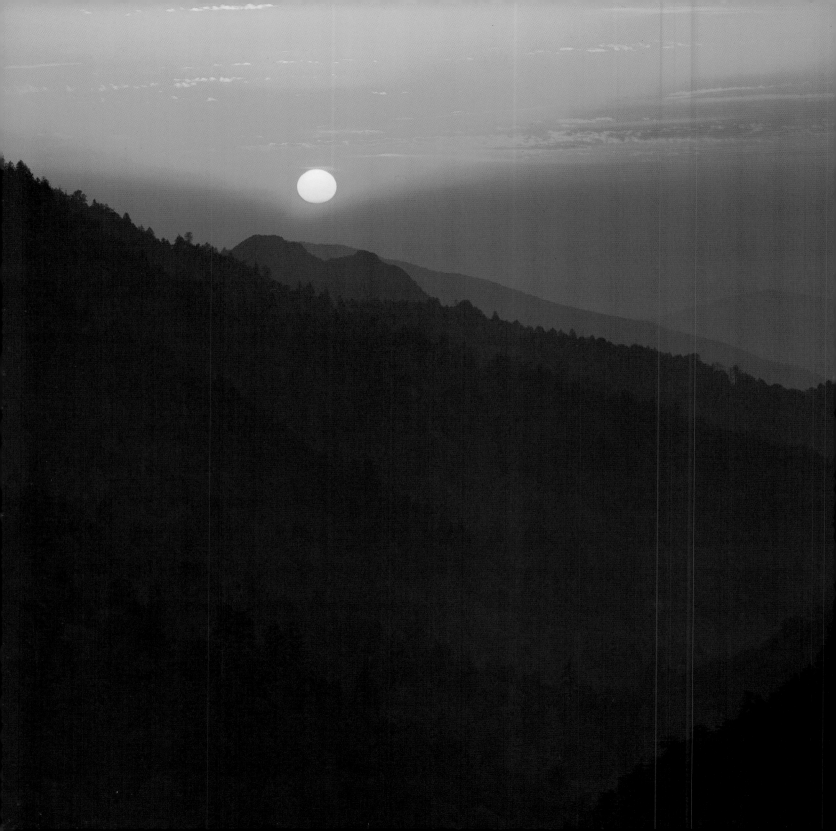

S UNSET HUES OF red and purple descend on the Chimneys, Great Smoky Mountains National Park.

Previous page: Dogwood cloaks a streambed in the Smokies. Hard hit by the dogwood anthracnose fungus, these beautiful trees struggle to survive.

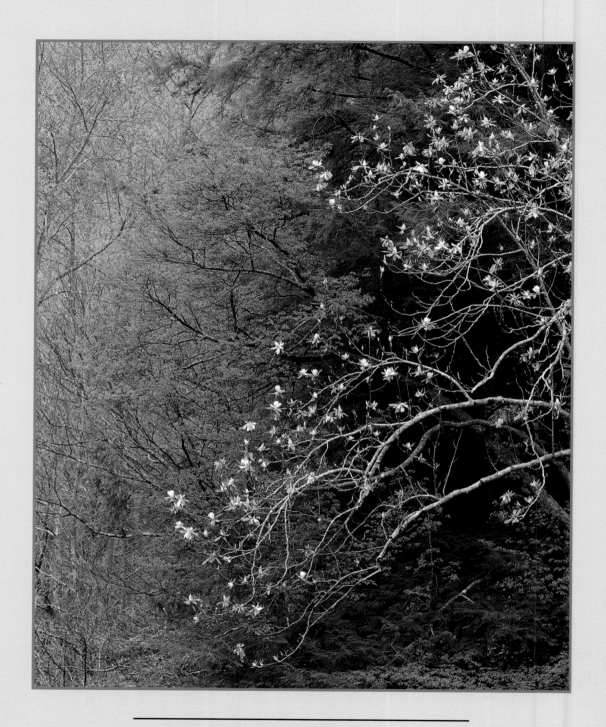

Fraser magnolia in bloom.

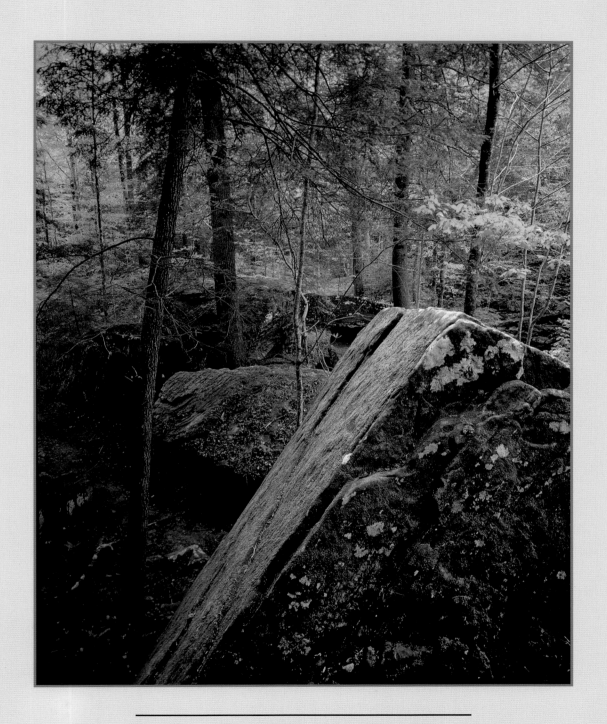

At the bottom of Fiery Gizzard Gorge, a long canyon at the
edge of the Cumberland Plateau.

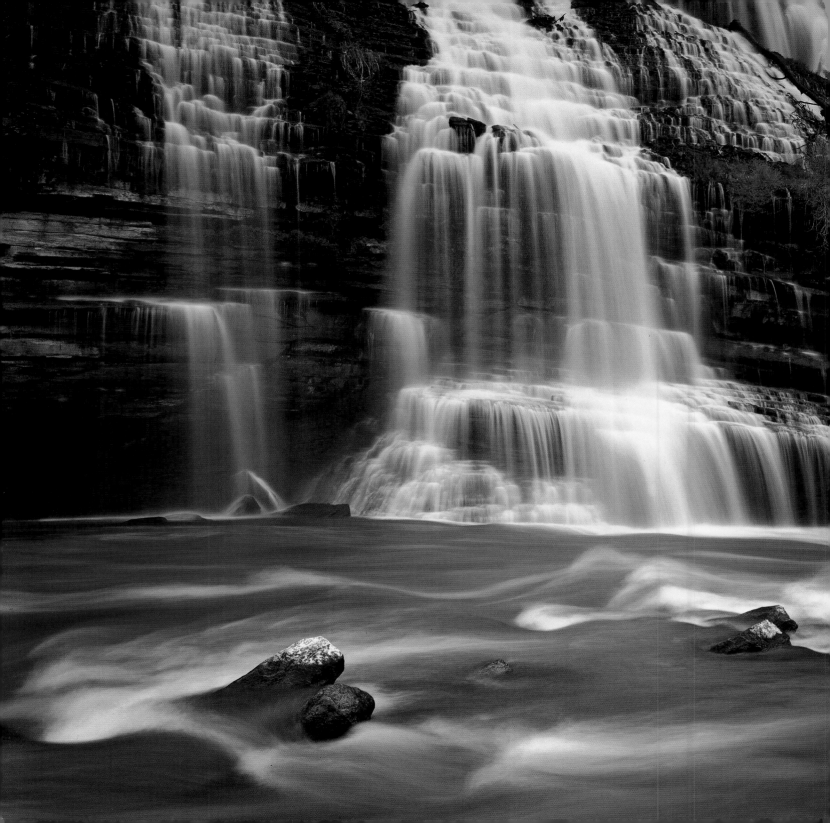

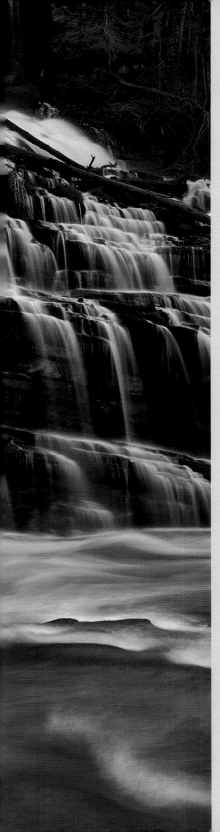

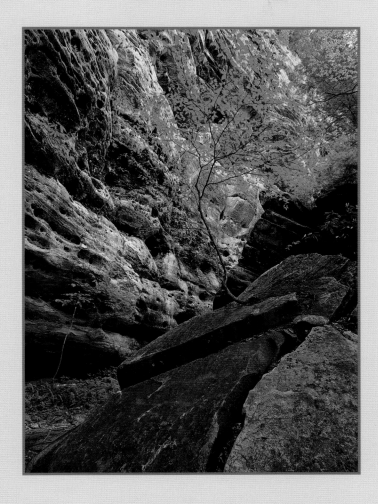

T UMBLING CASCADES of the Great Falls of the Caney Fork River.

Above: Where seed can lodge, tree will grow. Pogue Creek area, Cumberland Plateau.

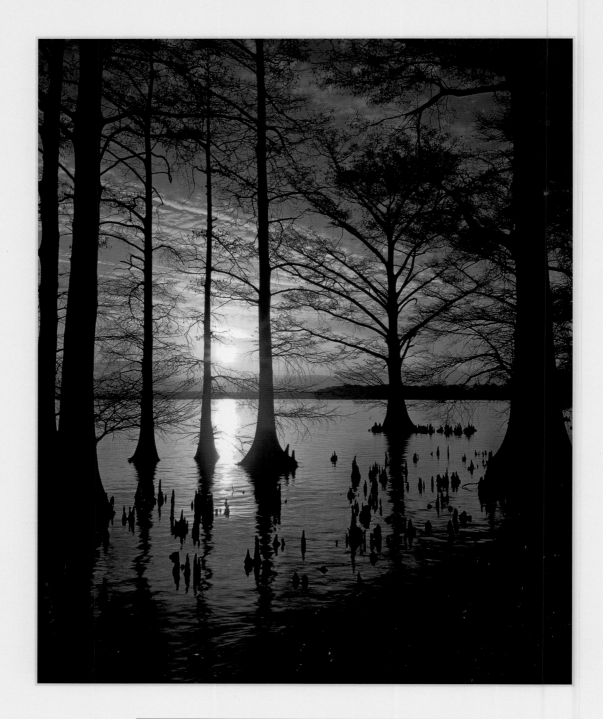

Reelfoot Lake sunrise.

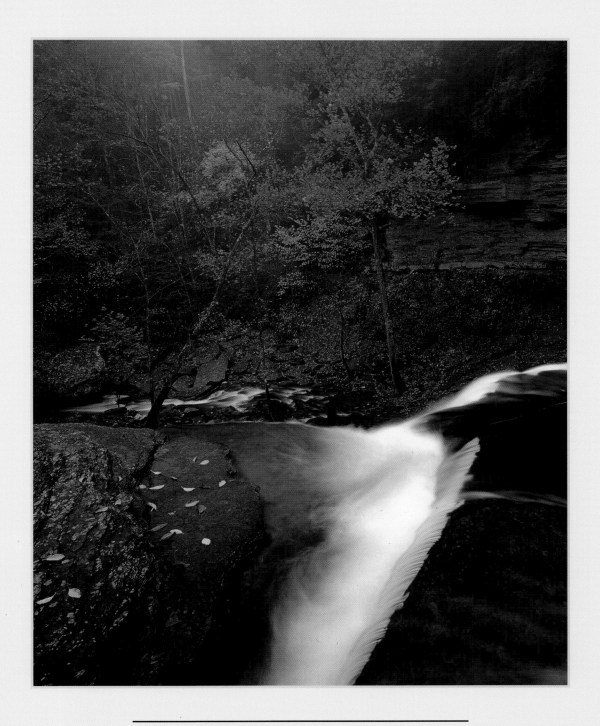

Lower Greeter Falls, located in South Cumberland State Park.

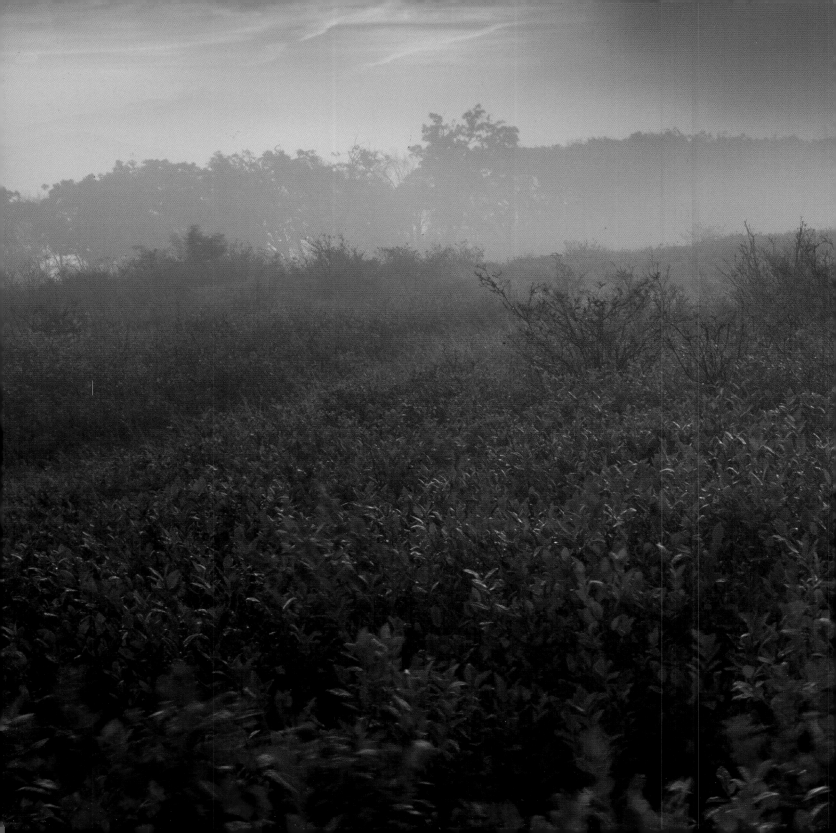

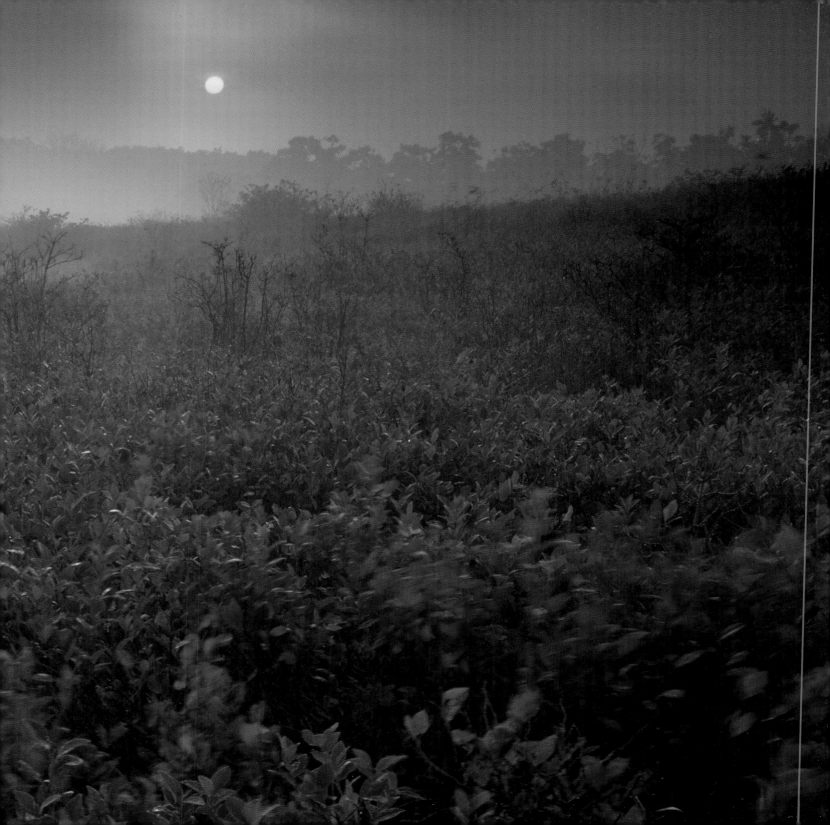

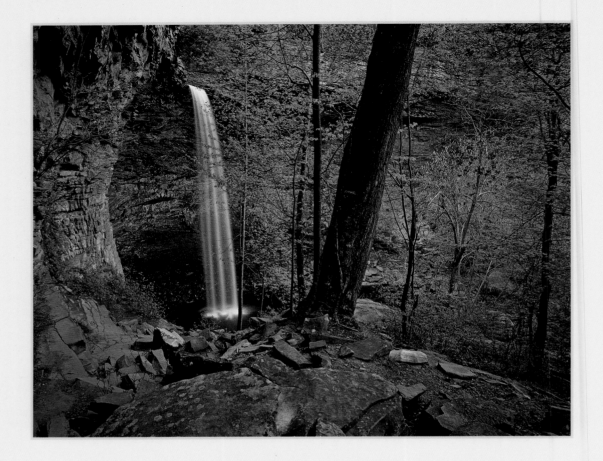

Above: Ozone Falls plunges 110 feet over sandstone rock into
a deep pool.

Previous page: Blueberry bushes turn crimson in autumn on
top of Gregory Bald in the Great Smoky Mountains.

Back cover: Rippled rock and rhododendron on the summit of
Jane Bald, located in the Roan Highlands.

About the Photographer: Nye Simmons has been capturing special natural moments on film since the early 1980's. His work has been published in regional as well as national publications, books, posters, calendars, and exhibits. He makes his home in Knoxville, Tennessee with his wife Deborah, and when home from college, his two sons, Nye and Lee. Nye was co-author/photographer of *The Smoky Mountains Photographer's Guide.* This is his second book.

More of Nye's images may be viewed on his website, **www.simmonsphotoarts.com**.